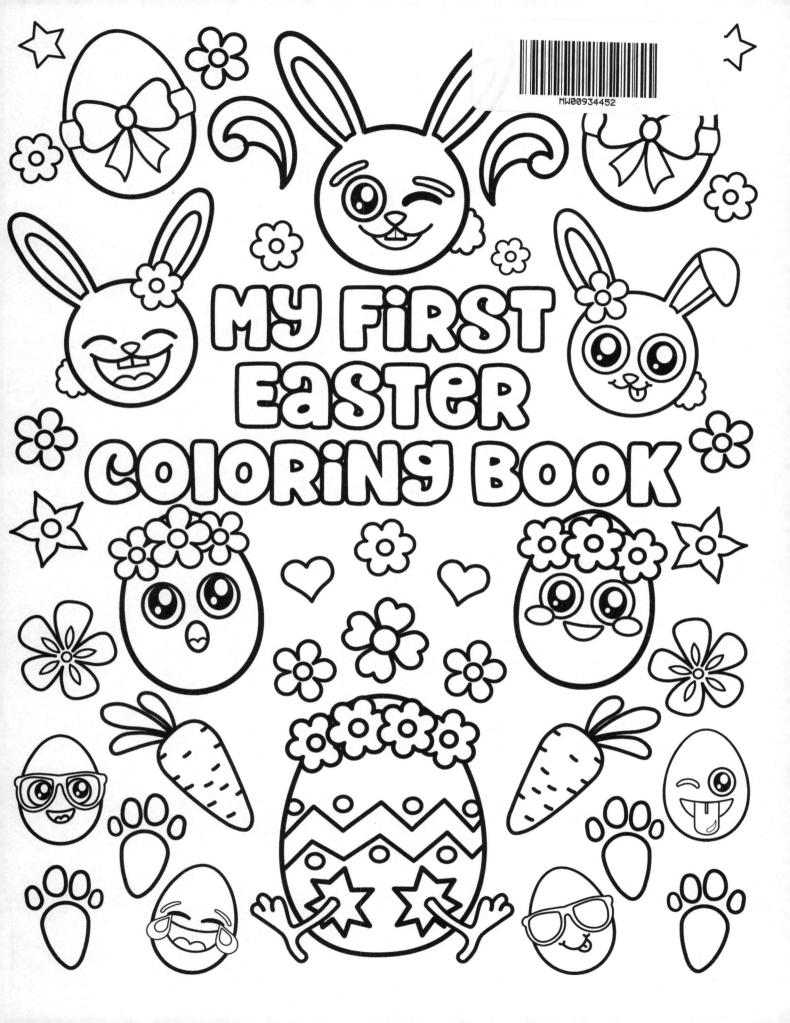

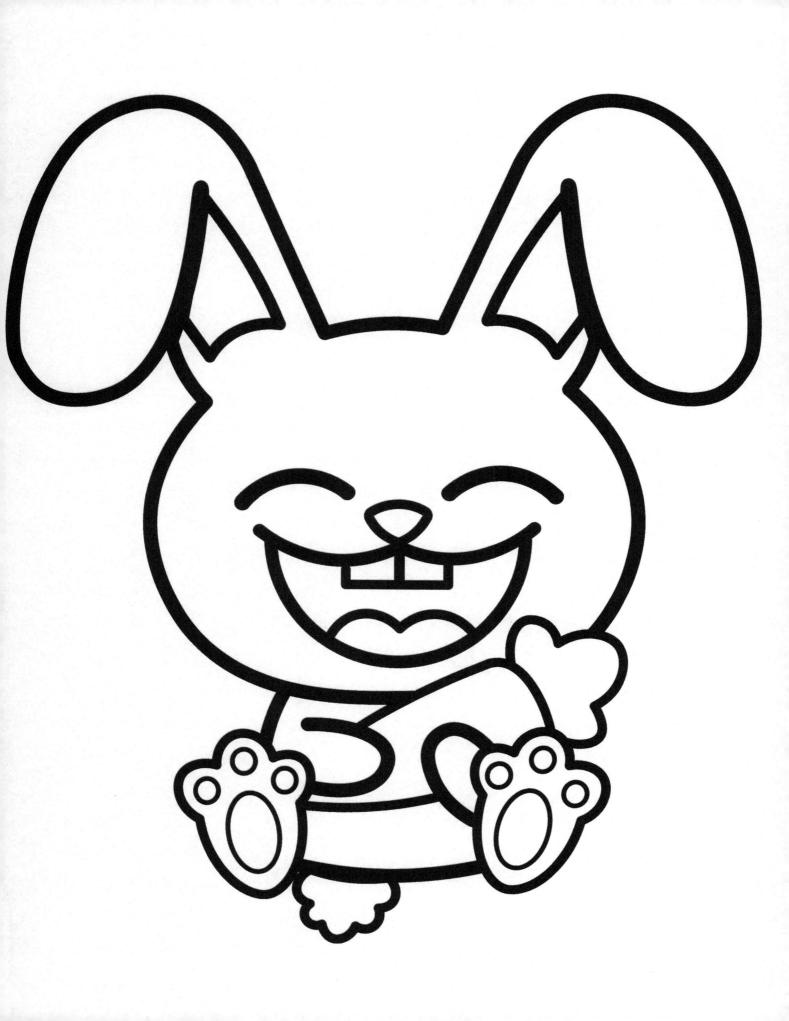

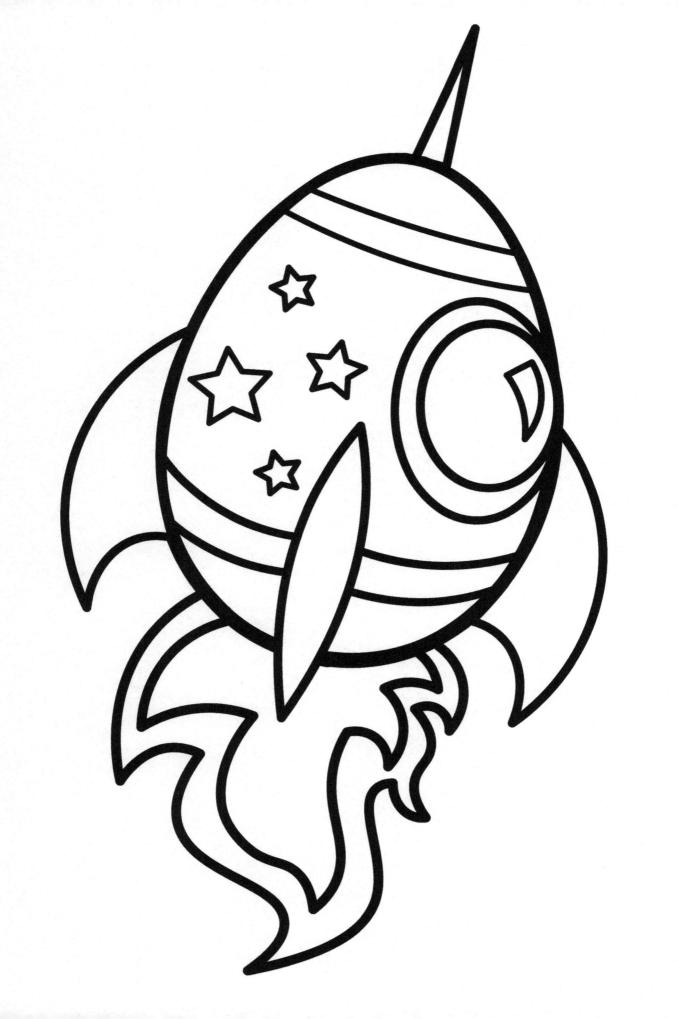

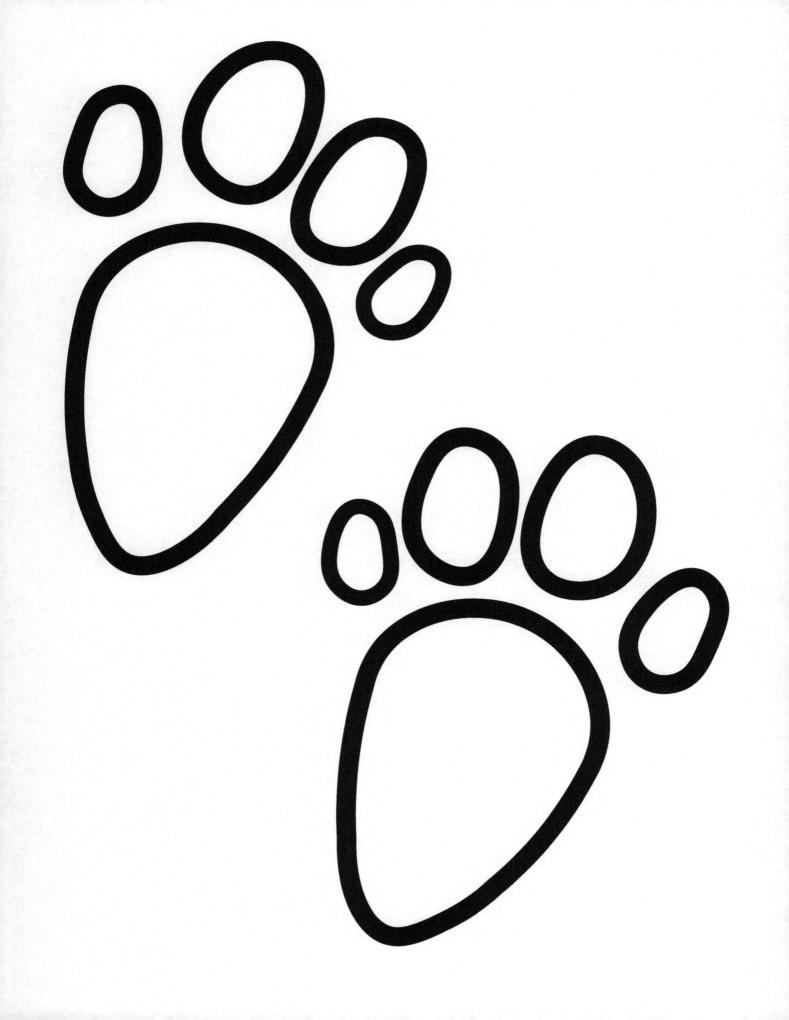

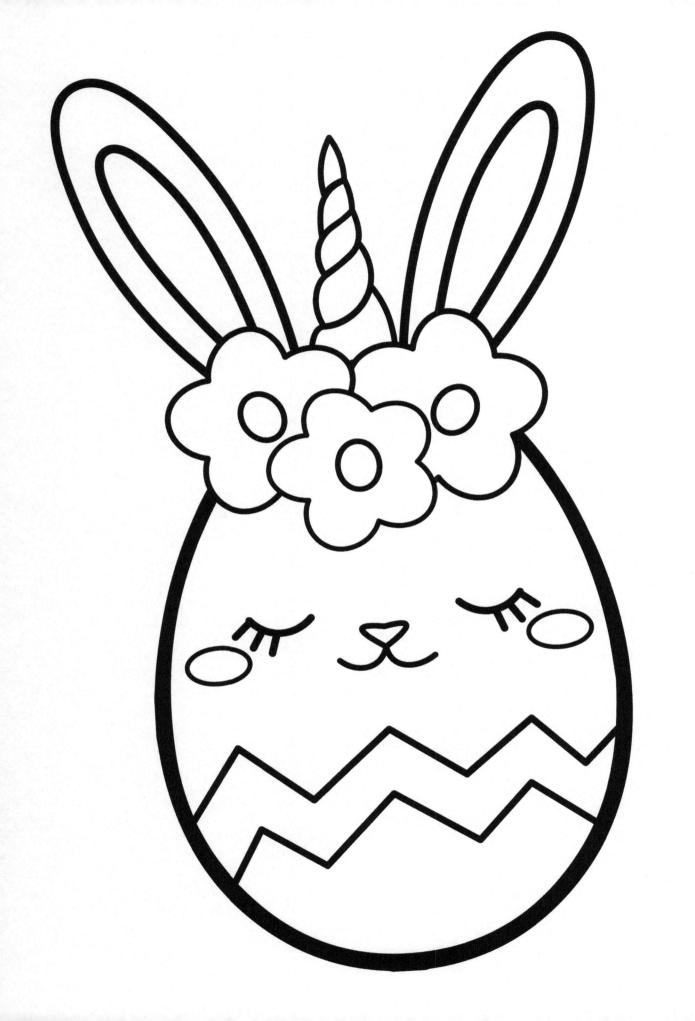

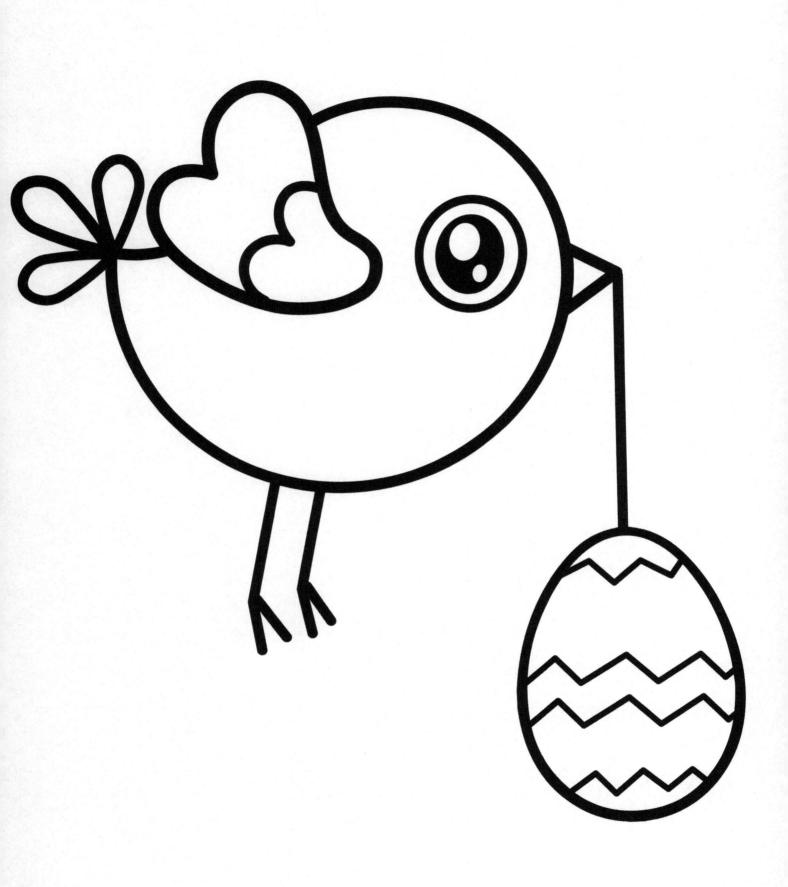

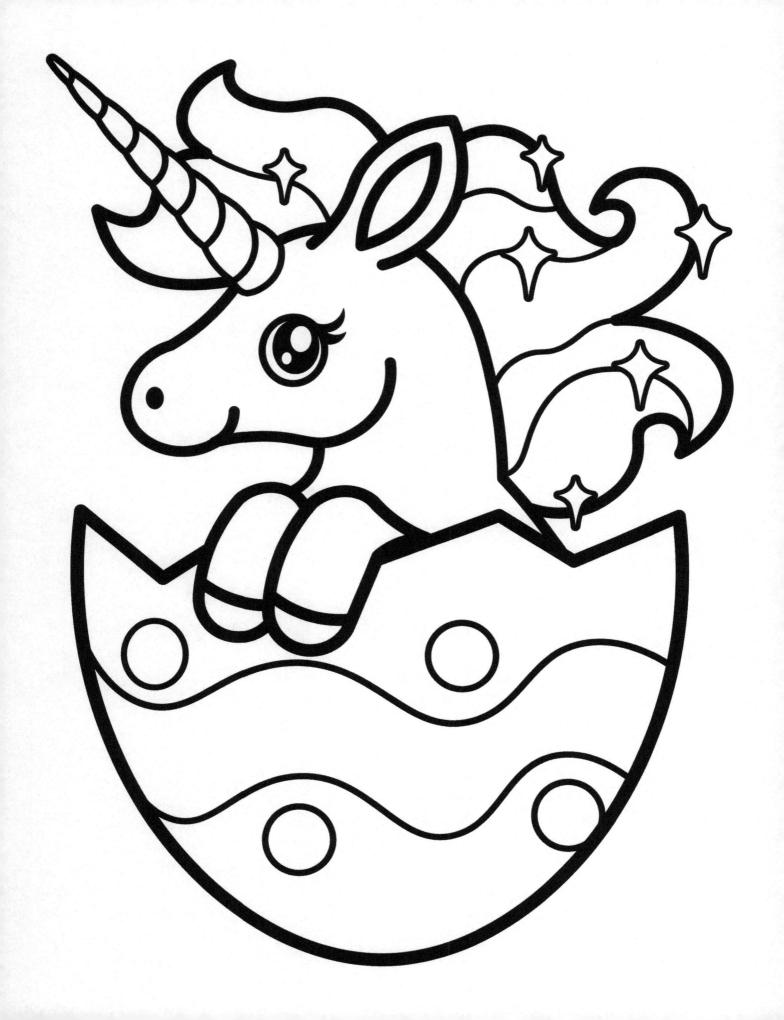

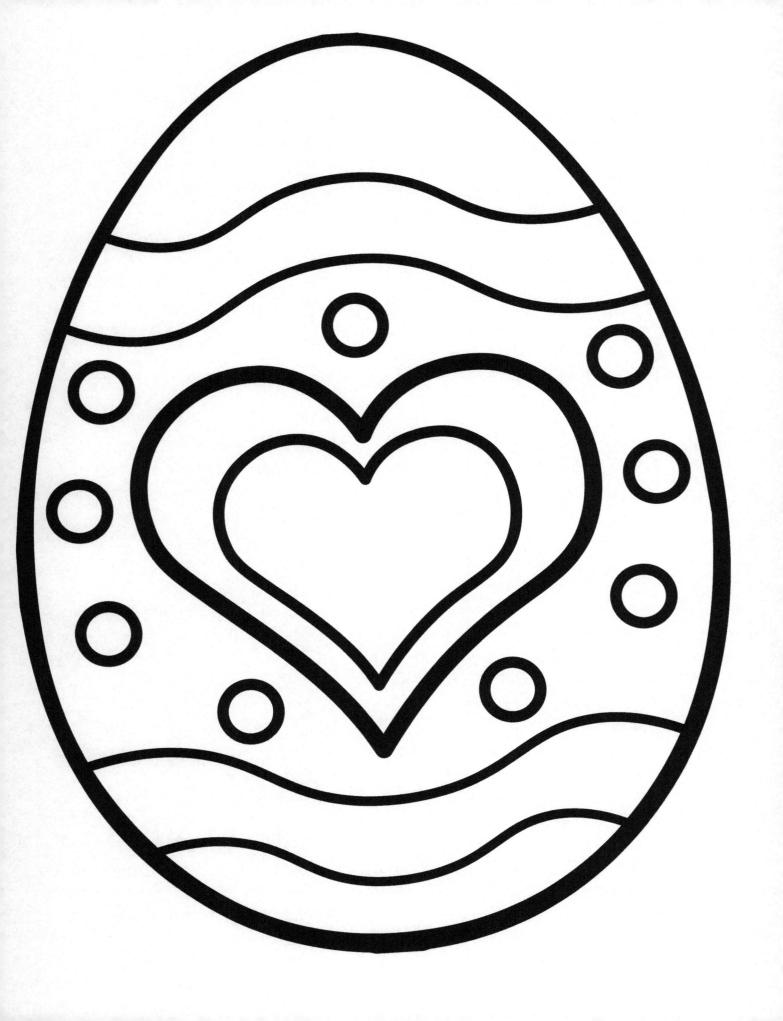

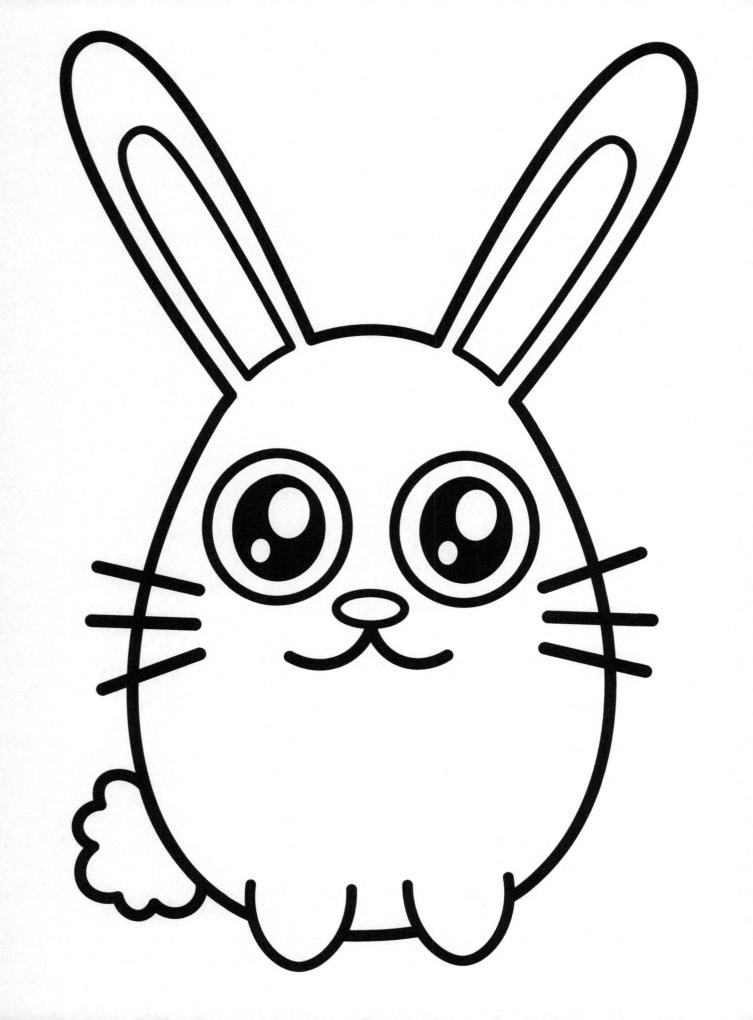

Also by Nyx Spectrum:

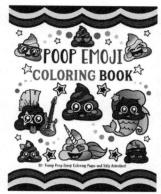

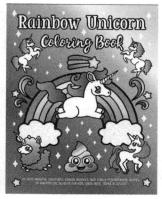

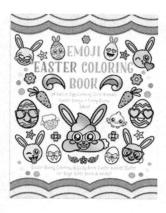

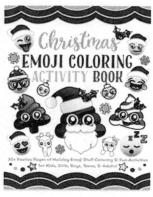

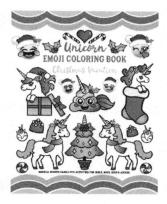

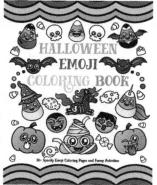

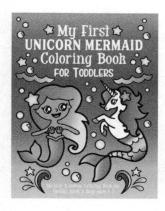

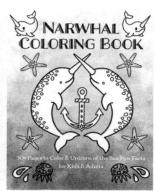

Made in the USA Middletown, DE 09 April 2020

88803519R00051